# *Accessorize Life*
# With Confidence

## HOW TO BECOME A SUCCESSFUL FEMALE ENTREPRENEUR

# KRYSTAL DUCKETT

Dedication Page

*To my beautiful daughter, Karter Sevyn-Rose Hayes,
and loving baby brother Marquis Duckett*

*Inspiring our young female entrepreneurs
of the world*

*An intelligent and confident mind is
a beautiful weapon of fate*

*—Krystal Duckett*

The Mind Is Like an Umbrella. Its Most Useful When open.

—Walter Gropius

# Table of Contents

# 1 – Thinking Hat

*The Power of Wishful Thinking*

*Learn to Overcome Fear and Become a Risk Taker.*

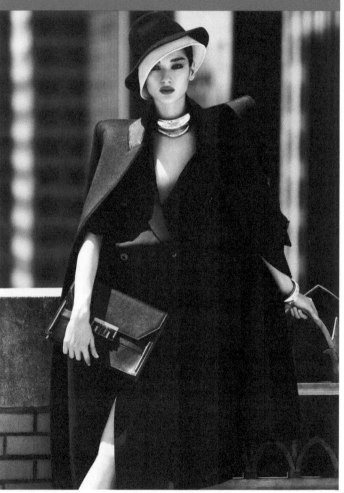

# Everything You Want Is on the Other Side of Fear

As I walked down the street, hands in my pockets, with pebbles of the rain hitting hard on me, each drop coming at me like a deliberate hit as punishment for all the years I spent in my shell, I took myself on a trip down the lane of memories that I could no longer resist. Tears rolled down my cheeks as though a prompter has beckoned them. I think of how it started, making a conscious effort to ensure that my fears would never be faced again. At least not until I am ready, I always told myself, and realizing now

that I was never going to be ready made me cry even more, for now my fears are behind me.

I always do not want to remember the dark start, because I had made the choice to shut out that memory, but now I think of it like it happened just yesterday.

My past fears as a child made me the strong, successful woman I am today. Not only am I an author, but I also own several fashion boutique companies, I am real estate investor, I am mentor to others, and I am the ultimate entrepreneur.

Here is a short glimpse of the child I once knew, facing a tragic fear.

A mouse once roamed around freely in the dwellings of an eleven-year-old child's bedroom. The child was very much afraid of the unwanted guest. The more the child thought about the mouse, the quantity of mice increased until eventually the entire home was infested. The mice taunted the child. She would have severe nightmares, causing her to be awakened drenched in cold sweat. The child made complaints to her parents, but they did nothing. The

drug-addicted stepfather of the child laughed at her, stating, "It's just stupid rats. What are you afraid of? Don't bother them, and they want bother you."

One night the stepfather caught one of the mice and held it captive. He yelled out the child's name with excitement. The child came running to her stepfather's call, and he asked her to boil him a pot of water. The child didn't think much of this request, assuming the stepfather probably wanted her to cook him some ramen noodles or something. The child would soon find out her assumption was wrong.

The stepfather ordered her to bring the boiling pot of hot water outside and instructed her to lay the pot on the porch of their apartment. The step-father than forced her to stay. He picked the mouse up by the tail with a grin on his face. He plunged the mouse into the boiling hot water. The mouse cried. The child trembled at the sounds of the mouse screeching in despair. She covered her ears while tears raced down her face as she was forced to watch.

The stepfather yelled at the child for crying and threatened to whip her. Over time he continued to capture mice and repeated this torture. He always said he was making an example of the mice, but his red blush and the looks in his eyes revealed amusement. The grin on his face as the mice overheated and cooked to death made the child more petrified.

He said often, "It's just stupid rats. What are you afraid of?" He then laughed. His voice lingered in her head.

Was the stepfather insane, cruel, or trying to force the child to become fearless of rodents?

By the time the child was seventeen, the stepfather had died from an overdose and her mother passed away shortly afterwards from AIDS, leaving the teen to care for a younger sibling. Childhood experiences such as the mouse story made her become a fearless monster when it came to entrepreneurship and success and made a better life for her and her younger brother.

Now you maybe wondering who the child maybe be and I must admit it is me. And now when I think

of my past, I think of the legendary Batman, Bruce Wayne, who conquered his fear of bats, and by becoming fearless, he conquered being a successful businessman and hero of Gotham City. But the difference between us is that I didn't inherit a bunch of money or a business. I had to start from the bottom and build my businesses from the bottom to the top.

Fears are ideas or self-opinioned negative thoughts that we create in our minds. Being brave doesn't mean you do not have fears; it means you have the courage to master your fears. If you want to be successful and have the life of your choice, you have to conquer your mind. If you wish to do so, please continue reading, because this book was designed to help you make your dreams come true.

When my mother passed away, I pondered whether or not she had dreams and ambitions for things she wanted to accomplish. Did any portentous dreams die with her? What could have possibly held her back from her dreams? Was she satisfied with our lack of sufficient funds to live a comfortable lifestyle? She always said not to be like her but

be better than her. What does that mean? These questions would build a tremendous desire for me to become the opposite of her and answer these questions for myself.

Take a second and think about your occupational dreams. Fantasize about your wants. What kind of environment do you wish to live in? What kind of car do you wish to drive? What kind of business do you wish to develop? Now think about what is holding you back from obtaining those dreams. I am willing to bet it is fear.

At this very moment, I challenge you to face your fears. I challenge you to understand that you are in a mental battle against yourself. Picture yourself as a beautiful bright hummingbird singing, soaring, and sufficiently great. Do not let your fears and insecurities shoot you out of the sky. Instead fire back at them with confidence.

To be confident and overcome fear you should accept healthy risk. To do so you must comprehend the worst-case scenario of the risk. Although you should hope for the best, you must decide if you can

handle the worst-case scenario. Figure out what the reward will be if you take the risk. If the reward is a sufficient outcome, challenge the risk. As the old saying goes, if there is no risk, there is no reward. Review chart below to analyze your desires versus their risk.

| What is the GOAL? | What is the RISK? | What is REWARD? | What is the worst-case scenario? | What is the outcome if you do not try to accomplish the GOAL? |
|---|---|---|---|---|
| | | | | |

Remember to be smart about the risk you take as opposed to being irresponsible and making bad choices. The successful people of the world are successful because they have a high tolerance for challenging risk. Even if they fail, they are happy with the worst-case scenario because of the experience and knowledge they gained. Look at it like this: if you are successful in the risk, be grateful. If you fail, still be thankful because now you are wiser.

When you apply for a job, what is the number-one thing the employer cares about? Experience. The employer will hire someone with experience over a person with a degree and no experience. Why is this true? It is because nothing can replace experience. Think about your favorite athlete. What do you think inspired your favorite athlete to be a winner? It was the experience of losing.

The only thing that can make your dream unattainable is the fear of failure. Remove yourself from your current comfort zone, because playing it safe is the biggest component of failure. Allow your determination for success to be your momentum. It is okay to develop your skills or talent over time, but you have to start working toward your dream while you have the momentum to do so. Use the power of momentum to steer your ambition, expectations, focus, effort, attitude, and environment. The successful people of the world are rewarded for what they practice. Nothing happens overnight.

When you observe life, you start to understand that you have two choices. You can either choose

to be a winner or choose to be a loser. The character of a winner is the ability to recognize that you deserve to win. You experience life only once, so I strongly encourage you to start practicing what you desire today, because we all know tomorrow isn't promised. Be persistent with the mindset to challenge yourself. Believe in your ideas and make them happen.

Surround yourself with people who have dreams and people who support your dreams. Never mirror nonbelievers. Don't listen to naysayers or people who say you can't succeed. Set the tone and express your belief, and you will notice nonbelievers will convert to believers, because of your proven actions. If you believe you are good at your craft, versus hoping you are good at your craft, you will visibly express that feeling. The belief will lead you to appear more convincing and lead you to your best conclusions.

Every night take a piece of paper and write down what you want. Take that piece of paper and put it under the pillow you sleep on. You will notice that

you will start dreaming of your wants, and whatever you dream, you can have in reality. You will wake up with a purpose. Every day will be a mission.

Remember to stay positive and not allow doubt in your mind. If you let doubt creep in, your ideas will be jeopardized. You will wake up one morning and see someone else living in the neighborhood you wished to live in, driving the car you wished to drive, or running the business you wished to develop. Such disappointment will leave you thinking that it could have been you, if you had focused a little harder and stayed positive and confident that you could reach your goals.

The point of this chapter is for you to understand that you can accomplish anything and everything you want if you let go of fear and take a leap of faith in yourself. The reality is that your success rate is measured by your ability to become a believer. Once you are a believer, risk and fear are simply just four-letter words.

Review the poem below and ask yourself, are you mentally free?

## ONLY A PERSON WHO RISKS IS FREE

*by Leo Buscaglia*

To laugh is to risk appearing the fool.

To weep is to risk appearing sentimental.

To reach for another is to risk involvement.

To expose your ideas, your dreams,

before a crowd is to risk their loss.

To love is to risk not being loved in return.

To live is to risk dying.

To believe is to risk despair.

To try is to risk failure.

But risks must be taken, because the

greatest hazard in life is to risk nothing.

The person who risks nothing, does nothing,

has nothing, is nothing.

He may avoid suffering and sorrow,

but he cannot learn, feel, change,

grow, or live.

Chained by his attitudes he is a slave

who has forfeited all freedom.

Only a person who risks is free.

# 2 – Pump It Up

*The Steps to Success!*

*Learn Success Preparation.*

# Chase Your Dreams, in High Heels, of Course

SUCCESS IS A lifestyle strategy that becomes a part of your everyday process. Being successful requires exercising your mind and taking action. Determine what you want and write it down. Set a deadline to achieve your want. Once you have your idea deadline, make an organized list of the things you must do reach your want. Next you can take action.

To take action you must have a budget. Decide the price you are willing to pay to achieve your want and start paying it. Your investment doesn't

necessarily have to be money. Invest time and energy.

Every day you should be doing something that will move you forward in the direction of your dream. Dream achievers work on their want and reward themselves along the way, so every time you complete a task on your organized to-do list, I want you to reward yourself. Be proud of the steps you are taking toward success. You deserve a pat on the back.

The point of working so hard is to enjoy life when you are not working. Separate working life from living life. Living life is the reward.

Let's start with step one. There are several classifications of goals. The elements of life are personal, family, health, education, and career. They all go hand-in-hand if you have the right mindset as a foundation. This book is more focused on the career aspect.

How do you determine what you want? Take three to five minutes and do a self-assessment. Think about your self-image. Visualize your life

mission and goals. Have an emotional attachment to your strengths.

In the chart below jot down all the goals you have for yourself. On the second chart, prioritize them. On the third chart rewrite your top three goals in detail, and be realistic.

| LIST OF GOALS |
| --- |
| 1. |
| 2. |
| 3. |
| 4. |
| 5. |

| PRIORITIZE LIST OF GOALS |
| --- |
| 1. |
| 2. |
| 3. |
| 4. |
| 5. |

| TOP 3 GOALS IN DETAILS |
| --- |
| 1. |
| 2. |
| 3. |

Now that you have brainstormed your goals, let's continue with a self-evaluation. Think about your weaknesses first. In the chart below write down your weaknesses related to your top three goals. Think about how you will confront those weaknesses. Ask yourself if you have any help in overcoming those weaknesses.

| TOP 3 WEAKNESSES | KEY HELPERS |
|---|---|
| 1. | |
| 2. | |
| 3. | |

I like to focus on my strengths and overcome my weaknesses along the way. When you primarily focus on your weakness, you divert to blaming your weakness for your lack of success, so know your weaknesses upfront and use your strengths to build yourself and overcome those weaknesses.

In the chart below write down your personal strengths associated with your goal. Think about what motivates your strengths. Think about how you would focus and prevail.

| TOP 3 STRENGTHS |
|---|
| 1. |
| 2. |
| 3. |

Step two addresses how to decide your deadline. It depends on how soon you want your goal. The timing is in your mind. To accomplish your goal, you must take one step at a time. Do your research, analyze your opportunity, and seek training. The best thing you can do for your sense of self is to set and achieve deadlines. Once the goal is set, track your progression toward the goal.

Make sure you give yourself realistic cushion time to meet your goal. Don't underestimate yourself in the process. Set high expectations, though, and don't let yourself down.

| GOAL | REALISTIC DEADLINE |
|---|---|
| 1. | |
| 2. | |
| 3. | |

Step three lets you strategize your idea to-do list. You must have a formula for success. Break your list down to two lists. The first list will be your Strike list. I call it the Strike list because you need to strike now. The second is called the Guide list, because it guides your wealth. Identify the objective of the goal and create your list in a logical sequence.

Examples of what a Strike Guide list would consist of.

| GOAL | STRIKE LIST | GUIDE LIST | DEADLINE |
|---|---|---|---|
| OPEN A SUCCESSFUL RESTURANT WITHIN ONE YEAR | • Determine your offering and market of demand<br><br>• Understand your competition<br><br>• Determine your marketing strategy<br><br>• Determine your startup cost<br><br>• Meet your legal requirements<br><br>• Develop your business plan<br><br>• Get help | DEVELOP BUSINESS STRATGY | BY JUNE |

| | STRIKE LIST | GUIDE LIST | DEADLINE |
|---|---|---|---|
| | • Pick the type of entity you will operate under and have a tax ID number | DECIDE BUSINESS NAME | BY JULY |

| GOAL | STRIKE LIST | GUIDE LIST | DEADLINE |
|---|---|---|---|
|  | • Microloans<br><br>• Community Advantage loans<br><br>• SBA 7 (a) Small business loans<br><br>• Investors<br><br>• Personal savings<br><br>• Crowdfunding<br><br>• Peer-to-Peer Lending<br><br>• Credit Unions | **OBTAIN FINANCING** | **BY AUGUST** |

| GOAL | STRIKE LIST | GUIDE LIST | DEADLINE |
|---|---|---|---|
| | • Research different locations. Gather information about the demographic and economic characteristics of the areas you're interested in.<br><br>• Find out about other businesses in the area<br><br>• Research your competitors<br><br>• Contact local councils<br><br>• Consider the current and future needs of your business | **FINALIZE BUSINESS LOCATION** | **BY STEPTEMBER** |

| GOAL | STRIKE LIST | GUIDE LIST | DEADLINE |
|---|---|---|---|
| | • Determine his/her responsibilities | **HIRE LEAD CHEF** | **BY OCTOBER** |
| | • Develop your menu concept. First and foremost, ask yourself what you want your restaurant to be known for<br><br>• Develop a list of core ingredients<br><br>• Investigate your supply chain<br><br>• Cost out your menu items<br><br>• Visualize your plating and glassware<br><br>• Run a test kitchen | **DEVELOP MENU** | **BY THE END OF YEAR** |

| GOAL | STRIKE LIST | GUIDE LIST | DEADLINE |
|---|---|---|---|
|  | • Make sure you have an EIN (Employer Identification Number)<br><br>• Set up records for withholding taxes<br><br>• Define the role you're hiring for<br><br>• Find your candidates<br><br>• Conduct interviews<br><br>• Run a background check<br>• Make sure they're eligible to work in the U.S. | **HIRE & TRAIN STAFF** | **BY FEBRUARY** |

| GOAL | STRIKE LIST | GUIDE LIST | DEADLINE |
|---|---|---|---|
| | • Hold a soft opening to test the waters with friends and family<br><br>• Set an official grand opening date<br><br>• Create your restaurant opening invitations and flyers<br><br>• Put together a marketing plan<br><br>• Book live entertainment<br><br>• Arrange decorations as well as grand-opening gifts for your guests | **GRAND OPENING** | MARCH 15 |

Your daily Strike Guide should consist of five to ten to-dos. Never overwhelm yourself with unrealistic productivity. Think about how you will win, what tools you need to get you there, what is the fastest path to your goal, and what you will receive in return. Ask yourself these things while creating your lists, and as you complete a task on your list, simply strike it out.

| GOAL | STRIKE LIST | GUIDE LIST | DEADLINE |
|------|-------------|------------|----------|
|  | 1. |  |  |
|  | 2. |  |  |
|  | 3. |  |  |
|  | 4. |  |  |
|  | 5. |  |  |
|  | 6. |  |  |
|  | 7. |  |  |
|  | 8. |  |  |
|  | 9. |  |  |
|  | 10. |  |  |

Step four, how do you take action? You take action by applying yourself. Once you get in the motion of doing the things needed to achieve your goal, you will get the fuel to continue to do those things and

more. Implementation is key. Don't let weaknesses hold you back. Figure out and overcome the weaknesses as you go.

How do you effectively track your progress? Prepare a performance analysis. Evaluate the outcome that is in your control. Get mentors for feedback, tips, and guidance. Don't be afraid to intern. Internships are great because you gain experience at someone else's expense.

Ask yourself questions when evaluating your success. Is my strategy working? Has my surrounding moved in the direction of my goal? Has my budget increased? Asking yourself these questions will help you gain control of your desire.

Keep your mission your main priority. If you put your mission first, your decision-making skills will be disciplined. Refresh your skills, because practice is perfection. Be consistent with your goal. Do not give up. If you make a mistake, learn from it, and take accountability for the mistakes made.

Let's recap this chapter. So far we learned four steps of preparation for success. Write down what

you want. Set a deadline to receive your want, and organize the things you must do to reach your want. You can then act. Take control of your lifestyle, because your lifestyle is your success.

# 3 – Hand Bag of Class

*The Significance We Carry!*

*Learn How to Set Self-principles and Core Values.*

# Strive Not to be a Success but Rather to be of Value

YOU SHOULD JUMP out of bed enthusiastically. Do a little dance, if you have to. Being eager and excited boosts your confidence. In this chapter we will discuss self-principles and values that will help build your character in business.

Let's start with the essential. Energy! You absolutely need energy if you really want to build confidence around your success. To maintaining a high level of energy you should maintain proper resting, eating, and exercising habits. Let these habits

guide your behavior throughout the day while you fulfill goals. Having the proper mental and physical health is the key to delivering your best efforts.

Now we can identify value and fundamental development. You call the shots in your life. Make your goals durable. Analyze everything you do. Review results and improve with effective and efficient changes. Growth creates value. Don't be a blamer or a person with excuses. Be accountable for your performance and the performance of your business, good or bad. If bad, remember never to make the same mistake twice.

Be optimistic when challenging your comfort zone for goals. Understand you can't do everything at once. When you do too many things at once, you tend not to do everything to your full potential. Take pride in what you do. Take your time and do it right.

Have strong morals and let your morals dictate your actions. Retain authority by setting high ethical standards for yourself. Have a level of respect for associates. For people to associate themselves with you, you must lead by example. If you are

being disrespectful to others, you can't expect others to respect your power. Make it your priority always to be on time and ready. Never be afraid to ask for help. Be transparent and direct when speaking.

Maintain a positive attitude and engage only in conversations that benefit you. Have a sense of integrity when making a commitment to yourself and others. Always remain willing to listen to and understand others. Be consistent with training and bettering your quality.

Inspired principles and values are the elements to better your conditions. They keep your life in order, and they open up time for exuberance and creativity. Enhance the world with great solutions to problems or challenges. Wealth will be the least of concerns when you are a problem solver. Have a purpose and pursue it with the right product, team, and customers. Create a business plan and passionately execute it. Share your dream by living it.

On the chart below write down the principles and values you want to live by. Build your character.

| CORE PRINCIPLES & VALUES |
|---|
| 1. |
| 2. |
| 3. |
| 4. |
| 5. |

# 4 – Bright Future Shades

*Look Good, Feel Good, Do Well!*

*Learn How to Appear Confident.*

# Confidence is the Best Outfit

YOUR ATTITUDE AND sense of style will advance attention toward you. Being physically at ease and comfortable in your skin enhances your confidence. Utilize good posture verses being to relax and slouching over. When you are speaking project your tone, so others can have a clear understanding of the words. Always smile to seem more approachable.

Being physically fit and healthy is also a confidence booster. People who are fit are often considered more propelled in business. People who are not physically fit could be misjudged or characterized as indolent. Furthermore, engaging

in vigorous physical exercises can reduce personal pressures or stress, enhance your imagination, and increase your creativity. Most of all exercising can improve your focus, energy, and wellbeing.

Now let's get into nutrition. You have to eat like a business owner. Go into your kitchen and remove all the unhealthy junk food. Although we all love sweets, fried food, and fast food, junk food suppresses the brain's memory, acquisition of knowledge, and appetite, causing diseases such as dementia, diabetes, depression, and more. Your capability and efficiency are influenced by what you consume. Your diet should consist of water, non-fried chicken, fish, fruits, vegetables, and whole grains. Also try eating organic.

The way you carry yourself dictates your skills in your profession. Always remember the first impression in business is infinite, so keep your hair clean and neat. Always make sure your nails are trimmed and clean underneath. If you like your nails polished, make sure to maintain the polish, never allowing it to be chipped. Exfoliate and keep your skin

moisturized. Use a good face wash to eliminate or avoid blemishes, pimples, or bad acne. Avoid overloading makeup. Keep your makeup light, natural, and professional. Never sleep in makeup either, because it ages your face.

Dress impeccably. Your goal is to appear experienced. Wear ironed, fitted clothing (a nice dress, suit, or slacks with a leather belt and a collared shirt). Always wear leather shoes (high heels or flats). Never wear baggy or loose clothing. Non-leather shoes appear cheap and unprofessional. Add polish to your attire with a pair of diamond stud earrings and a nice watch. Don't wear gaudy jewelry.

You are a walking billboard for your company. Know your company's mission when engaging in conversations. Keep business cards and advertising specialties (pens, T-shirts, etc.) handy with your logo on them.

The chart below is a seven-day confidence challenge. Appearing confident is key in success. Prepare yourself by getting in the habit of living a confident lifestyle.

| 7-Day Challenge | Monday | Tuesday | Wednes-day | Thurs-day | Friday |
|---|---|---|---|---|---|
| 30-Min-ute Exercise | | | | | |
| Eat Some-thing Nutritious | | | | | |
| Hygiene: Skin Care Hair Nails | | | | | |
| Coordi-nate 7 profes-sional looks | | | | | |
| Write down 10 things about your busi-ness | | | | | |

| 7-Day Challenge | Monday | Tuesday | Wednesday | Thursday | Friday |
|---|---|---|---|---|---|
| Smile & make eye contact with 7 people | | | | | |
| Introduce your business to 7 people and tell them 3 things about your business | | | | | |

# 5 – A Diamond Statement Piece

*No Pressure no Diamond!*

*Learn How to Shine Under Pressure.*

# Eat Diamonds for Breakfast and Shine all Day

ATTITUDE IS EVERYTHING to an entrepreneur. You may have the right strategy to get your business off the ground, you may have enough capital to make a grand entry to the next level, but if you don't have the right attitude, you may own a business, but it won't succeed. Before you join the throng of countless entrepreneurs who had to learn the importance of attitude to business success through bitter experience, here is a list of attitudes you must adopt, develop, and apply consistently in your business.

## *Value Innovation*

Many people own businesses for the wrong reasons. They want to be rich, have affluence, and oppress their neighbors. They desire business success for the wrong reasons, and such attitude affects how they handle their profits and utilize their resources. You must have an attitude that values innovation. You must seek to create value and solve an existing human problem with your products or services. Successful business owners have a common factor, and that is their commitment to innovation and value creation.

## *Passion*

If you care about value, you must of necessity operate within the area of your passion. You can't remain committed to a business you are not passionate about, especially in the face of daunting challenges. Every business experiences ups and downs, and if you are not passionate about your involvement, you'll eventually burn out. Passion fuels consistency, which is needed to run a business

successfully. Your attitude in business should be distinctly measured, and the direction of your vision should be a product of your passion. This saying captures it well: "Don't climb your business ladder only to learn it is leaning against the wrong wall."

## *Overcome Fears*

You need to deal with your fears, so they don't incapacitate you. Because fears come up time and again, you need to understand principles for dealing with fears. Although there's a popular adage that fears are not real, to the person feeling them they are quite real and must be tended to. Here are steps you can take to overcome your fears:

- ✓ Create a list of your fears.
- ✓ Separate the rational fear from the irrational fear.
- ✓ Distract yourself from the fears.
- ✓ Face fears one at a time.
- ✓ Prepare for the worst.
- ✓ Consider the evidence and facts/

✓ Visualize yourself in a happy state/
✓ Talk about your fears to people who can help.
✓ Get back to the basics.
✓ Reward yourself for facing and overcoming each fear.

Fears are often compounded by a scarcity mentality, which means you fear that there is a scarcity of resources or money. Scarcity mentality makes you think that things won't turn out well. Instead of a scarcity mentality, you should have a mentality of abundance. Operating with an abundance attitude keeps unnecessary panic away. Know that the universe has all the materials, resources, and money you need, and doing all the right things will bring that abundance to you.

## Collaboration and Cooperation

If you want to build a business that is bigger than yourself, you must know that nothing worth having is made alone, which is why having an attitude of collaboration and cooperation is vital to

the success of your business. Many business own-ers have been driven out of business because they were too competition-conscious, when they could have gained a lot from cooperating with other busi-nesses and entrepreneurs. Part of collaboration and cooperation is listening to and working on is-sues provided in feedback from your customers and clients regarding your products and services. Carry your customers along, and don't always see every other business in your industry sector as a competitor. There are times when you can pull re-sources together to expand your reach into your target market.

## Flexibility

No matter how great you are at what you do, you will experience setbacks. There'll be hurdles to overcome on the journey. If you don't have the right attitude at such times, you may not pull through. You have to learn to manage disappointment and changes. You need to possess a flexible attitude, so you can identify and possibly alter a course that's

likely headed toward failure. Being flexible means that you are fine with modifying the route to achieve your established goal or, in some cases, tweaking the goal itself for successful execution.

In business inflexibility can sometimes be fatal. You can't afford to run your business with the "one way; my way" mantra. You need to listen to your customers' needs, track market trends, and sometimes pay attention to industry specialists. It is best to be open to suggestions, even those you won't take, rather than view them as a nuisance or interference. Be willing and ready to change, even if you don't have to.

## Humility

Everyone, including the proud, appreciates humble people. You have to adopt the attitude of humility to gain the respect that will connect you to bigger and better opportunities. Humility is not about maintaining a false façade; people will always spot a fake humble person. You may do successful things with your business, but don't be eager to be

recognized and celebrated for it. Being humble will help you focus on achieving even greater things.

You can assess your humility by examining how you interact with others in win and lose scenarios. Do you boast when you achieve a feat, or are you quietly confident? Not every quiet person is humble, but at least the quiet are not boastful.

## *Integrity*

Every business transaction is established primarily on trust. You must have an attitude of integrity, so it'll be easy for you to establish trust with your customers, employees, vendors, and investors. The importance of integrity cuts across all business sectors and applies to anyone who intends to build a brand that'll last. Integrity is one attitude that you need others to verify for you, however. You must be able to show others that you're trustworthy. There is no shortcut to building integrity, because the best idea will likely fail if the person in charge has questionable integrity. You have to stay true to your promise of delivery, cherish the contribution of your

employees to the company's growth, and be sincere in your presentation of the company's growth potential to your investors.

## Strong Work Ethic

Your efforts will directly contribute to the success of your business. You must have an attitude that encourages smart work and resilience. You must also be willing to learn new things about your field and the areas you intend to diversify into, so you'll always stay relevant. Be willing to work every day, but balance work with good rest, so you'll stay healthy. With a strong work ethic, you will always be productive, innovative, and adaptable enough to keep creating new products and actionable ideas.

# 6 – Timepiece

*I Can, I Will, Now Watch Me!*

*Learn How to Structure and Manage Your Time.*

# Time Management
# Is Life Management

TO MASTER YOUR time and live life to the fullest without guilt, you must first believe that you can control everything in your life. You must believe that you absolutely can control even the things you think you cannot control. The more you believe that you have control, the harder you will try to have control. Let's start off by breaking down your workweek into two types of days.

Focus Days are days that you will focus on daily goals centered on the growth of your business.

Free Days are days that you unwind and reward yourself for completing the activities of your focus days.

Decide which day or days will be your Free Days. On these days you will take the time to dream, relax, and live. Let's be honest. Besides working because we have passion, we also work to enjoy ourselves when we are not working. Reward yourself for your self-discipline and self-satisfaction of goals you have achieved. By doing so you are creating a work and life balance that will increase your happiness.

To have control of your Focus Days, you must understand the value of well-defined goals and avoid mental procrastination. Well-defined goals are specific, realistic, and timed. Focusing on your goals is a way of life.

Write your daily goals down from the most complex activity to the easiest activity. Be sure that the urgent and most important activities are prioritized. By writing down your daily goals and prioritizing the most important ones, you are planning your day and thinking about the upcoming future. Once you

write down your activities to complete, write down how long each one will take. Keep a positive mindset throughout the day. Desire it! Plan it! Imagine it! Do it! Keep doing!

Dreams go unfulfilled when you stress or allow procrastination in your life. Say to yourself, "I am in the mood to be successful" when you are feeling like you are not in mood. Everything we do is mental, so positivity is a must. Give yourself pep talks when you are feel stressed, and don't be afraid to ask for help from your support team.

Once you have completed your day, take time to analyze and study your written daily goals. Ask yourself questions to improve your daily goal planning for the next day. By doing this task daily, you will learn from your daily regrets and become more organized.

Please see the daily goals and time management chart below and write down your daily goals for tomorrow. The purpose of doing this exercise is to develop a clear objective every day to master your time. Time management achievers simply live better lives!

| Time | Mon-day | Tues-day | Wed-nesday | Thurs-day | Friday | Satur-day | Sunday |
|---|---|---|---|---|---|---|---|
| 6:00 AM | | | | | | | |
| - | | | | | | | |
| - | | | | | | | |
| - | | | | | | | |
| 7:00 AM | | | | | | | |
| - | | | | | | | |
| - | | | | | | | |
| - | | | | | | | |
| 8:00 AM | | | | | | | |
| - | | | | | | | |
| - | | | | | | | |
| - | | | | | | | |
| 9:00 AM | | | | | | | |
| - | | | | | | | |
| - | | | | | | | |
| - | | | | | | | |
| 10:00 AM | | | | | | | |
| - | | | | | | | |
| - | | | | | | | |
| - | | | | | | | |
| 11:00 AM | | | | | | | |
| - | | | | | | | |
| - | | | | | | | |
| - | | | | | | | |

| _Time_ | Mon-day | Tues-day | Wed-nesday | Thurs-day | Friday | Satur-day | Sunday |
|---|---|---|---|---|---|---|---|
| _12:00 PM_ | | | | | | | |
| - | | | | | | | |
| - - | | | | | | | |
| _1:00 PM_ | | | | | | | |
| - | | | | | | | |
| - - | | | | | | | |
| _2:00 PM_ | | | | | | | |
| - | | | | | | | |
| - - | | | | | | | |
| _3:00 PM_ | | | | | | | |
| - | | | | | | | |
| - - | | | | | | | |
| _4:00 PM_ | | | | | | | |
| - | | | | | | | |
| - - | | | | | | | |
| _5:00 PM_ | | | | | | | |
| - | | | | | | | |
| - - | | | | | | | |

| Time | Mon-day | Tues-day | Wed-nesday | Thurs-day | Friday | Satur-day | Sunday |
|------|---------|----------|------------|-----------|--------|-----------|--------|
| 6:00 PM | | | | | | | |
| - | | | | | | | |
| - | | | | | | | |
| - | | | | | | | |
| 7:00 PM | | | | | | | |
| - | | | | | | | |
| - | | | | | | | |
| - | | | | | | | |
| 8:00 PM | | | | | | | |
| - | | | | | | | |
| - | | | | | | | |
| - | | | | | | | |
| 9:00 PM | | | | | | | |
| - | | | | | | | |
| - | | | | | | | |
| - | | | | | | | |

# 7 – Signature Perfume

*The Invisible Yet Unforgettable Fragrant!*

*Learn How to Be Unforgettable by Creating the*

*Life of Your Dream.*

# *Be Fierce, Be Fearless, Be Unforgettable*

IT IS TRENDY to become an entrepreneur these days; however, many who started the race of entrepreneurship have ended it with a crash and are no longer in business. Many have had to revert to a regular nine-to-five job for subsistence. Perhaps they did not understand or follow the tasks required of an entrepreneur.

When you call the shots as the boss, when you're the person in charge, you become the solution provider, and no one pats you on the back for being

a responsible leader or working smarter and not harder. There's also no one to guide you through obstacles that may be in the way of success, and it can be daunting for the first-time entrepreneur to have no support. Despair and fear of failure may become your compass when you're dealing fruitlessly with a difficult client or lose out to a competitor or make a bad decision that puts your company in a delicate situation.

The biggest challenge you'll face as an entrepreneur is maintaining your cool and calm in the face of discouraging circumstances. You need emotional intelligence among other positive attitudes, mindsets, and dispositions to be a fearless and fierce entrepreneur.

Below are ways to become an unforgettable, successful entrepreneur.

## Enjoy the Journey

The ride to entrepreneurial success is both smooth and bumpy, high and low, and full of laughter and tears. The best way to succeed as an

entrepreneur is to enjoy every single moment of it. You can easily shy away from the hard work of entrepreneurship, but if you want to create a win-win scenario at all times, you have to be excited about every experience you get. It may not make you simply in the present, but you're bound to remember it with fondness.

## *Stay Motivated*

What are you passionate about? Why are you an entrepreneur? You must never forget this reason, if you want to grow as a fearless and fierce entrepreneur. If your motivation is to have saved up for a luxurious lifestyle by age forty, then you should put this goal in your happy list and view it often. If your motivation is the security that comes with being financially buoyant, then remind yourself of that fact every day, especially in the hard times.

## *Never be Idle*

A fearless entrepreneur is one who lives as if her life and that of other people depends on her

success. She doesn't have time to spare or waste on things that don't foster the fulfilment of her goals. Idleness breeds a lot of indecision that can put a careless entrepreneur at the bottom of the customer-consideration list. Spend your time innovating sustainable solutions that'll make you relevant to your target market and expand its reach.

## Learn from Your Mistakes

You will make mistakes and you need to forgive yourself; it's quite simple. Moreover, you must not allow fear to be your compass. Although you should tread carefully to ensure you don't make expensive mistakes, sometimes you can't escape even those. Let there be no error you can't overcome, but don't go out of your way to make mistakes, as they can be costly. The key is to set time aside to reflect on each mistake and why you made it. You should also take the responsibility for the error to ensure such mistake doesn't repeat itself.

## Adapt or Perish

Entrepreneurship is competition on a changing landscape. You either adapt or you die. However, many entrepreneurs fear change and are incapacitated by it. Constantly share and discuss ideas that can help you dominate your market. Your strength is in your ability to change, and your continued relevance is guaranteed that way. Enjoy your success and ensure that you never become complacent.

## Always Be on Your Toes

The hardest part of becoming an entrepreneur is branching out all on your own. Stay true to your dreams and be extraordinary in everything you do; however, don't be a workaholic who neglects other aspects of her life. You need to have the mindset that you're unstoppable. Give everything your best shot at all times.

## Seek Out Successful People in Your Field

You can't do everything alone, and as much as you need to learn from your mistakes, you're better

off learning from the experiences of established individuals in your field of endeavor. Fearless entrepreneurs are those who have gathered a wealth of experience that gives them confidence. Don't always perceive yourself as a threat to others. If they're successful in their field, chances are they think about how they can help others succeed.

You can reach out with an introductory email to ask for a specific amount of time while you outline the major points you want to discuss. Be respectful and have a flexible schedule so you can work around their schedules, since you are the one asking for help.

## Never Publicize Your Tension

You will be discouraged from time to time, which doesn't mean you are fearful or jittery. It just means you are human. Even on the worst days, though, you must never give up. Develop the mindset of being unstoppable and fight the negative emotions that may want to overwhelm your intellect and willpower. No matter how tough times are, let

your employees and clients see the fierce, fearless, strong, confident, and the best version of you every time. You can withdraw from public scrutiny to draw strength and inspiration in private, but don't be caught off guard in public.

## Join A Support Group

Entrepreneurship takes courage, and you need to be around courageous people to be courageous. Owning your own business is not a venture for the fainthearted. It is for those who can think, inspire, interact, and bring the best out in others. Funny enough, hanging out with members of your support group, even if it's to relax and play, has an immense benefit. For instance, playing chess or golf is one of the ways to develop your intellectual capacity. It is also during such light moments that vital information is exchanged for your next big business break.

## It's About You

The kind of person you are is the type of entrepreneur you will be. John Mason said obstacles are

the breakfast of champions. If you're able to remain strong and self-assured in the face of the greatest challenges, you are close to being an unforgettable entrepreneur, the kind that sets milestones for others to follow. Operate with vital principles such as honesty, integrity, transparency, and value delivery and stay true to those principles, no matter the cost, and you will be a fearless and fierce entrepreneur everyone wants to be like.

# Resources for Entrepreneurs to Boost Their Confidence for Start-ups

THERE ARE MANY resources out there that can help new entrepreneurs start and grow their businesses bigger and better, but there are also resources that seem to exist just to waste your time. Is there a way for you to tell the difference? This Book discusses the top resources from three aspects, to help you develop your confidence and enhance your productivity.

## *Websites*

### ForEntrepreneurs.com

ForEntrepreneurs.com is a website that is just as the name suggests. It is the result of David Skok's years of experience at Matrix Partners. He also has an MBA to complement his background, and his approach to startup techniques and financial modeling is user friendly while maintaining a strongly technical nature.

### Quora.com

Quora.com is many an entrepreneur's go-to site, because most reputable entrepreneurs and thought leaders in various industries come here to dole out relevant information. It's among the best websites to have your questions answered.

### AngelList.com

Do you need funding from angel investors? Created by Venture Hacks, AngelList.com is a platform that helps new companies get funding from

reliable investors. It includes templates to help you pay minimal attorney fees.

## Med ium.com

Founded by Ev Williams, the cofounder of Twitter, Medium.com is a platform for blogging. It also features suitable reads on careers from successful entrepreneurs and provides first-person perspectives.

## Entrepreneur.com

Entrepreneur.com is another helpful site for entrepreneurs, especially when you sign up for notifications or get the app to help you stay updated on the latest strategies and news about entrepreneurs.

## HBR.org

On HBR.org, The Harvard Business Review has blogs that provide insights on building startup businesses.

## KISSmetrics.com

More entrepreneurs are managing their own websites and thus need to stay on top of metrics. Kissmetrics helps you go above and beyond Google Analytics and provides a two-week free trial.

## QuickSprout.com

Entrepreneurs who manage their websites often need to learn the basics of search engine optimization (SEO). On QuickSprout.com Neil Patel teaches about how to generate the required traffic.

## TheStartupDonut.com

TheStartupDonut.com is a U.K. site with the tools and articles necessary to get your startup off the ground. It's particularly useful if you desire to go multinational.

## TED.com

TED.com features inspiring and revealing talks, and though the site isn't exclusively for

entrepreneurs, there's a strong community of successful business founders there.

## Under30CEO.com

Are you a young entrepreneur who dreams of making it big before the big 3-0? If yes, Under30CEO. com is a blog for you, but you can benefit from it even if you're beyond twenty something.

## TheEconomist.com

TheEconomist.com is not just for entrepreneurs, and it features commentaries that make it a requisite for any business professional to stay up to date on all news and develop essential business partnerships.

## YourSuccessNow.com

YourSuccessNow.com is a business blog designed to suit every industry. It is the go-to place for the support and encouragement necessary to keep moving forward.

## MarieForleo.com

Forleo is an immensely successful entrepreneur; however it's her personality and character that makes the MarieForleo.com blog a necessity. She's optimistic, bubbly, light, and she's experienced. Many readers find her inspiring.

## Forbes.com

Relationships are important in business. This is why it is crucial to remain updated on business news and Forbes.com is your go-to site to ensure this happens.

## *Learning Sites*

Being a successful entrepreneur, especially for a startup, means you have to wear a lot of hats. You may have to learn new skills, but you can, fortunately, benefit from free, high-quality, educational resources online. Here are some of such resources:

### CodeAcademy

CodeAcademy is a platform that offers free interactive programming sessions where you can learn programming languages such as CSS, JavaScript, PHP, and HTML. Open a free account to save your progress. Entrepreneurs who can code can fix bugs or build their own websites and apps.

### LearnVest

Successful entrepreneurs know how to manage their business and personal finances. In addition to having extremely affordable finance classes, LearnVest also offers some classes for free, such as How to Budget and Building Better Money Habits.

### MIT Open Courseware

MIT Open Courseware offers some courses for free on its site for viewing and reading at your discretion. These offerings include an entrepreneurship page that features available courses that are useful to new business owners, such as The Software Business and Early State Capital.

### Coursera

Similar to MIT's Open Courseware, Coursera has more than one hundred educational partners that provide free courses to about 10 million users. Coursera provides specialized courses for particular niches, such as University of Maryland's Innovation for Entrepreneurs: From Idea to Marketplace and Data Management for Clinical Research from Vanderbilt University.

### Saylor

The Saylor Foundation provides tuition-free courses and works with some accredited colleges and universities to offer affordable credentials. Its

course outlines are similar to the framework of a bachelor's degree.

## YouTube

YouTube is the world's number-one video content website for good reason; it features everything! From TED talks to recorded presentations on building a business, you can gain useful information on just about any topic.

## EdX

EdX is a free-to-use site with more than 300 courses on various topics such as Entrepreneurship 101: Who is your customer? and Financial Analysis and Decision Making. These courses cover business in general and also help you learn more skills in your industry.

## OpenCulture

OpenCulture is a site that collects and shares free resources and useful information from around the web. It offers 150 free online business media

in iTunes, video, and audio formats. The site also has free audiobooks, certificate courses, and online courses on other topics.

### Niche Consultant Courses

The internet has fostered and accommodated the coaching boom that has helped entrepreneurs who want to learn how to start or grow a business in a specific niche. Some great coaches and organizations that regularly provide free eBooks and courses on building a business include Natalie MacNeil and My Own Business.

### Podcasts

Podcasts are an amazing resource to help you become a better entrepreneur. You can listen to podcasts via computer streaming, iTunes for iOS, and apps like Podcast Republic for Android. Think Entrepreneurship and Entrepreneur of Fire are podcasts that have thousands of listeners each episode and are a great way to gain updated information and learn possible strategies.

## *Business Operations Websites*

BrandChannel.com

www.brandchannel.com

Run by the internationally acclaimed brand consultancy Interbrand, BrandChannel.com provides a global perspective on the art of branding and brands. The site features in-depth feature articles, career resources, conference announcements, and access to white papers.

Customer Service Group

www.customerservicegroup.com

Alexander Communications Group (ACG), a New Jersey-based company, owns the Customer Service Group website. It contains practical information for customer service professionals free of charge. If your tasks include customer relations, ensure you sign up for Service Starters, ACG's free customer service industry e-newsletter.

## Electronic Frontier Foundation
www.eff.org/issues/intellectual-property

Eff.org/issues/intellectual-property is owned by the Electronic Frontier Foundation, an organization that works to maintain balance and guarantee that the internet and digital technologies empower creators, scholars, innovators, consumers, and average citizens.

## Direct Marketing Association
www.the-dma.org

The www.the-dma.org website is controlled by the Direct Marketing Association, which is the largest trade association for businesses. DMA is interested and involved in direct, database, and interactive global marketing.

## AccountingWEB
www.accountingweb.com

AccountingWEB offers accounting industry news, tools, tips, information, and insight needed to interact with other accounting professionals. It is updated daily.

# Conclusion

*Life Has to Be Accessorized. And Confidence is Your Best Accessory, Never Start Your Day without it! – Krystal Duckett*

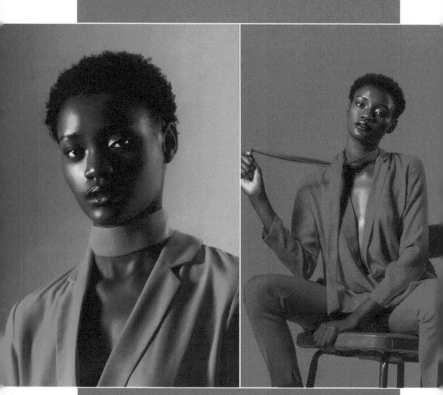

# *Conclusion*

*ACCESSORIZE LIFE WITH CONFIDENCE* demonstrates how to become a successful female entrepreneur. What you learn by applying each chapter is worth more than any precious metal. You have accrued knowledge on how to overcome fear, how to become a risk taker, how to set and achieve goals, how to value yourself, how to manage your time, and most of all, you've learned how to display confidence.

Thank you for taking the time to read this book. Remember to focus on your goals and work toward achieving them. Every progress, regardless of

how big or small, adds to your confidence. Confidence helps you be successful and live the happy life of your dreams. Here's to your success! You can do it!

## The End

Lightning Source UK Ltd.
Milton Keynes UK
UKHW052035190223
417162UK00001B/14